G000039746

Heroes
of the Revolution

American Cars and Cuban Beats

ear
BOOKS
MINI

Photos by Robert Polidori

Copyright © 2005 by edel CLASSICS GmbH, Hamburg/Germany
All photographs © Robert Polidori
Special-Car-Infos by Helge Thomsen and MB
Music copyright see music credits

ISBN 3-937406-53-0

Designed by Guido Scarabottolo and Raffaela Busia
Adapted for earBOOKS mini by Petra Horn

Produced by optimal media production GmbH, Röbel/Germany
Printed and manufactured in Germany

earBOOKS is a division of edel CLASSICS GmbH
For more information about earBOOKS please browse **www.earbooks.net**

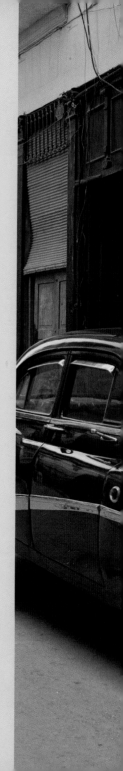

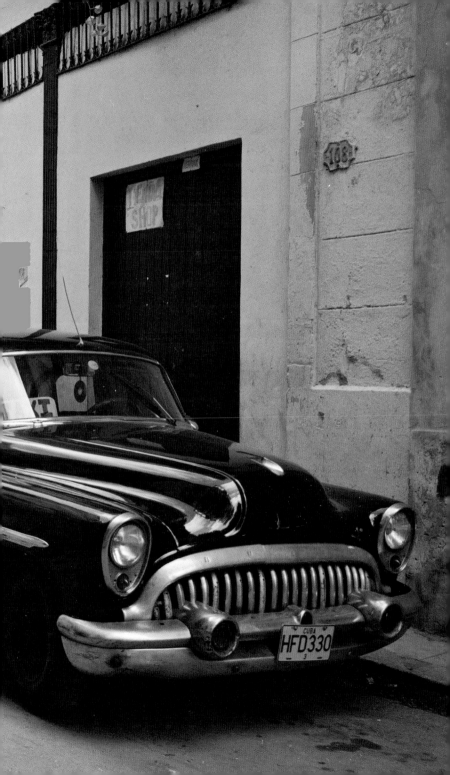

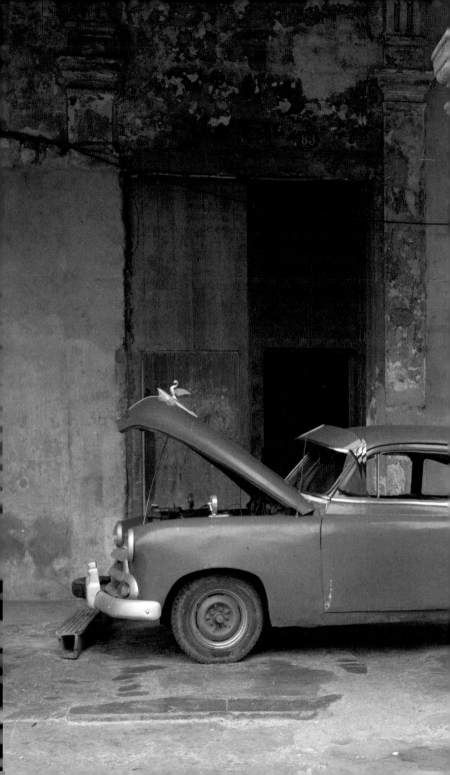

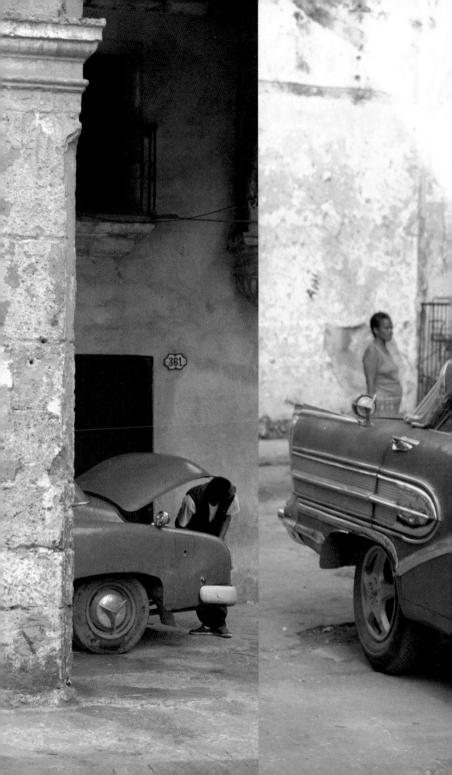

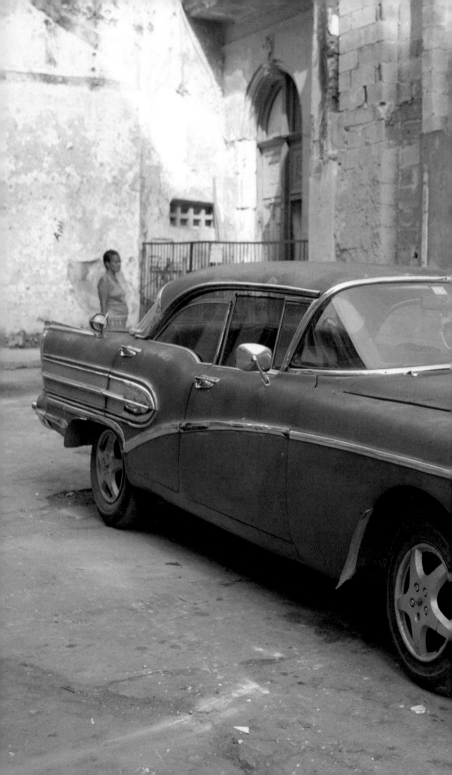

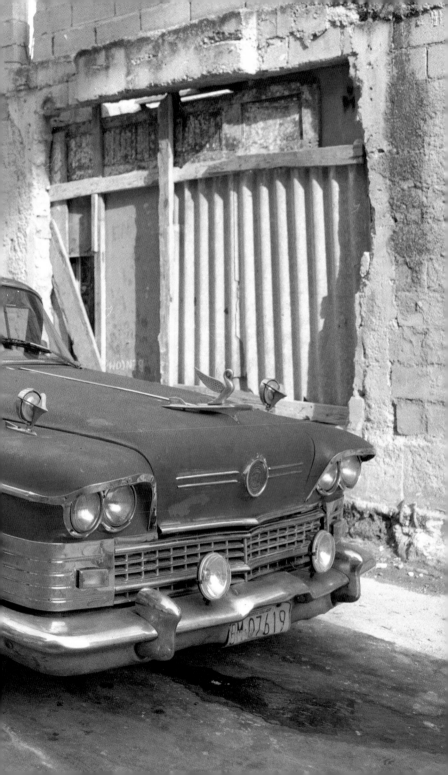

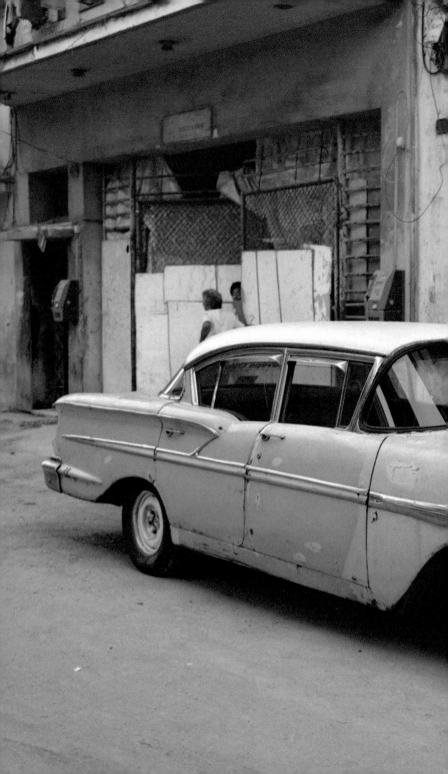

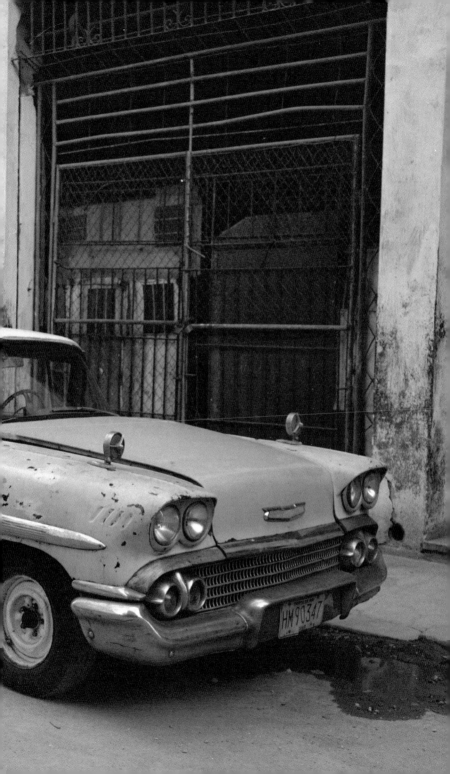

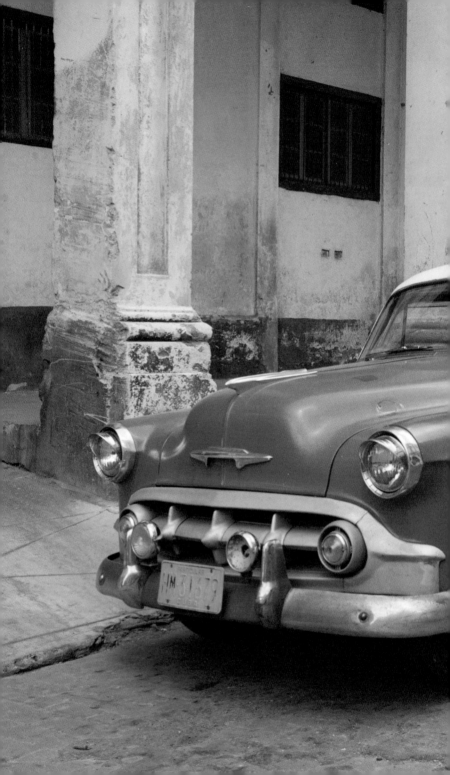

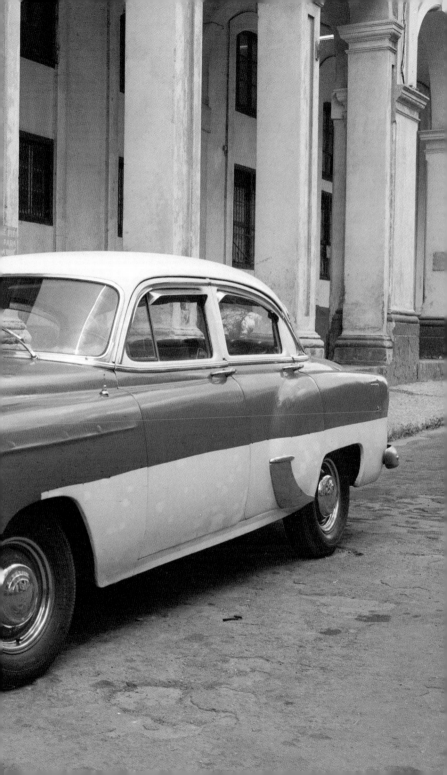

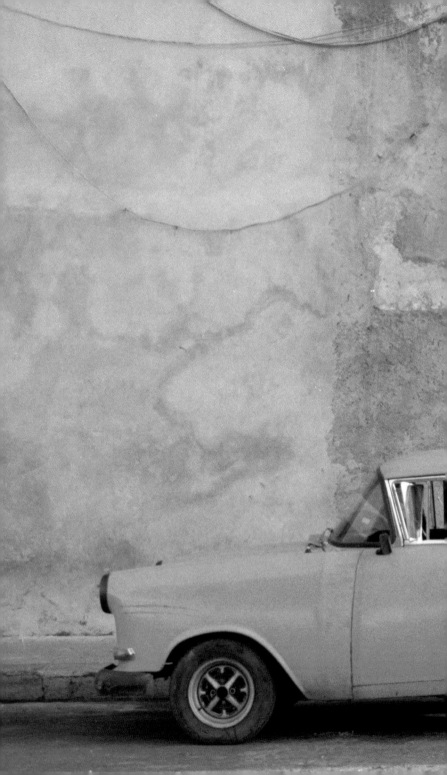

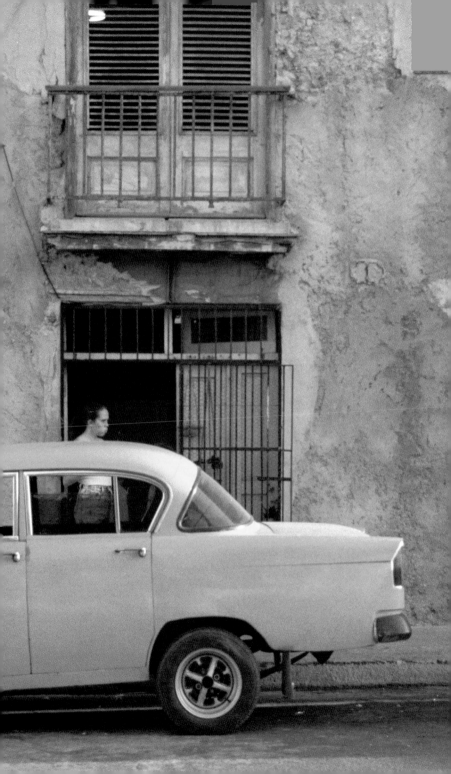

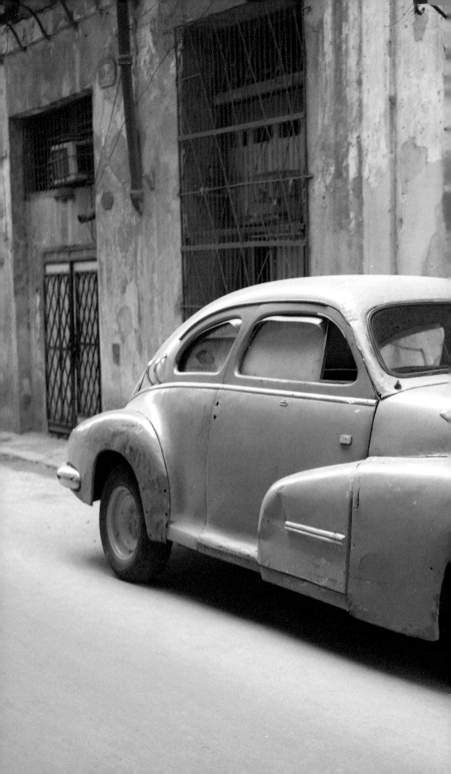

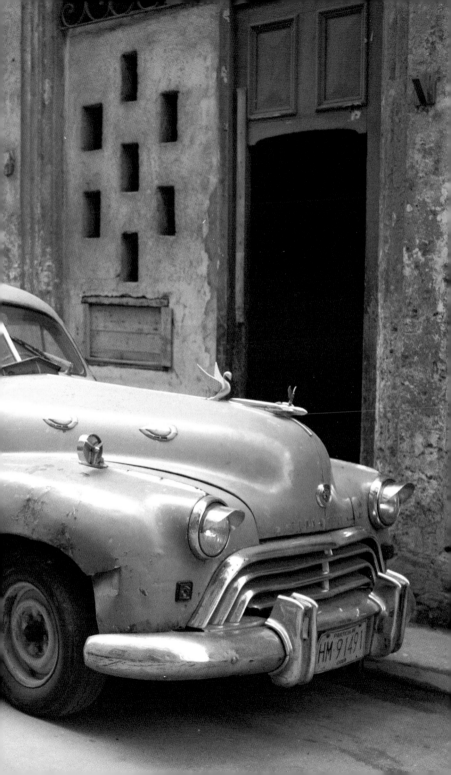

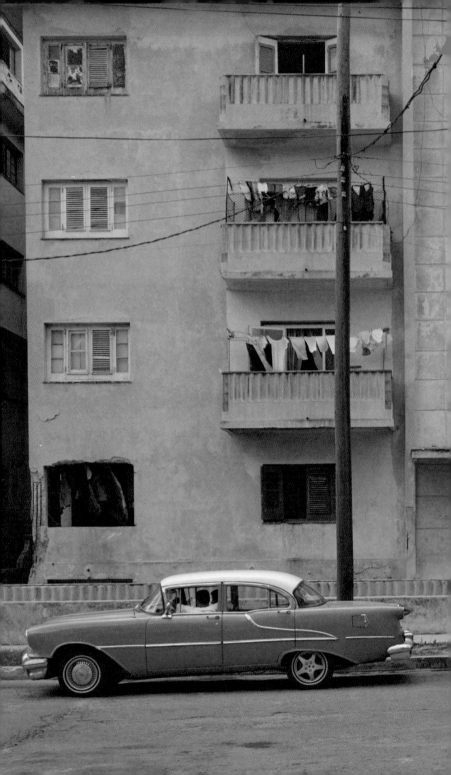

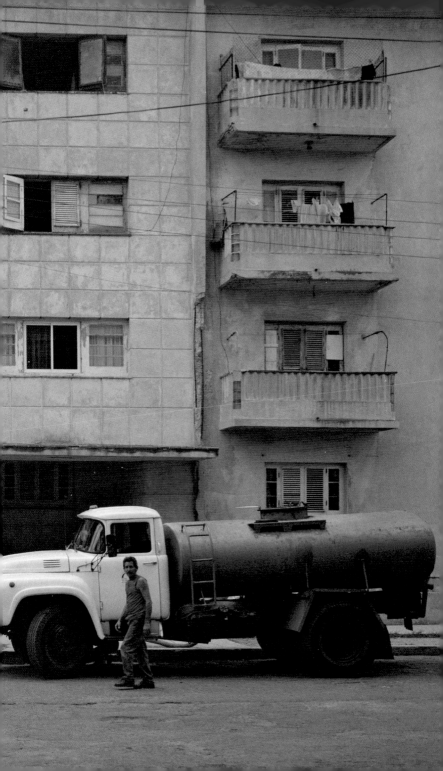

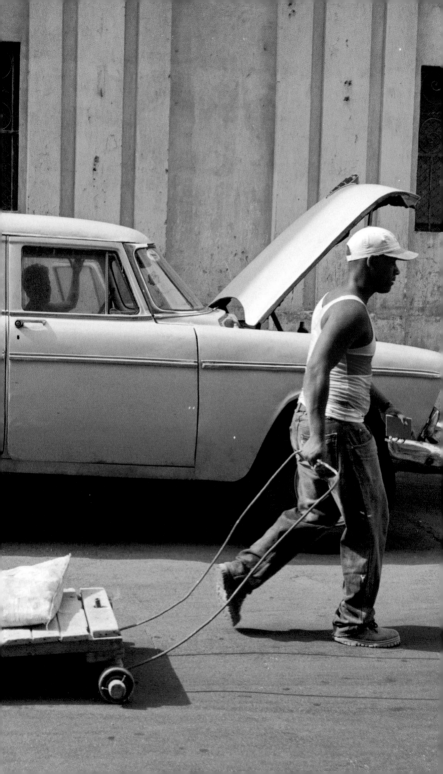

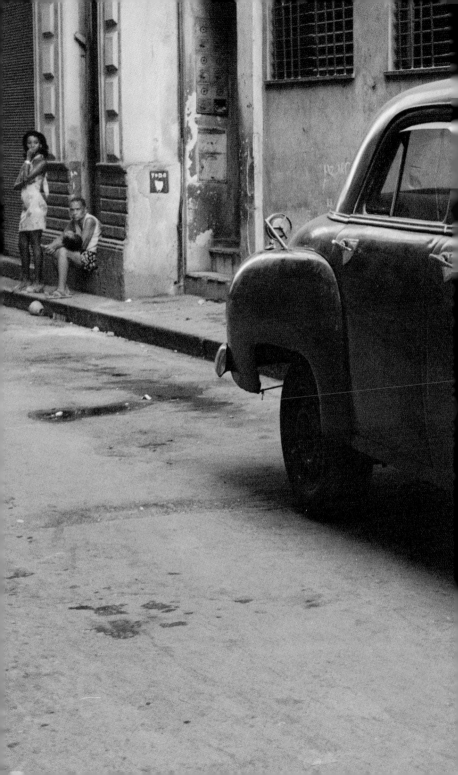

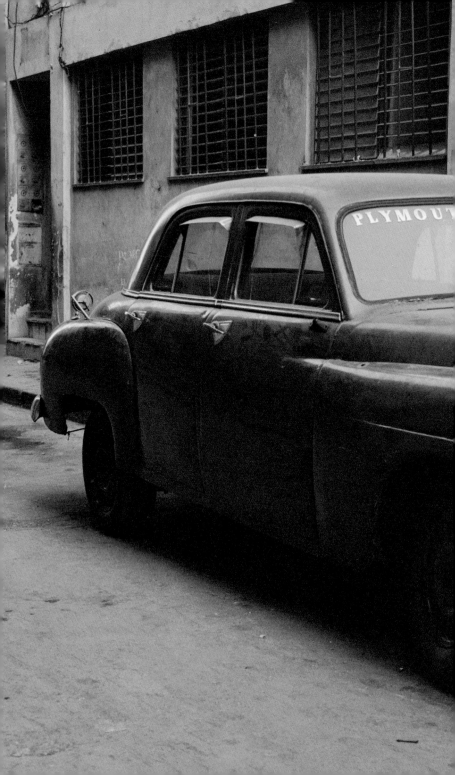

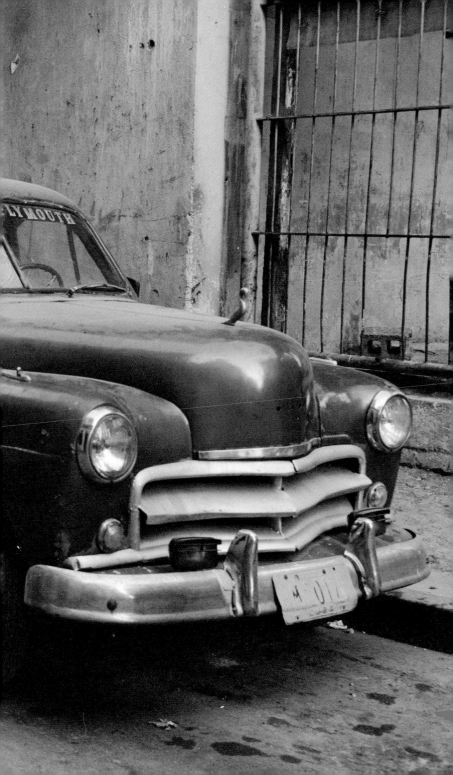

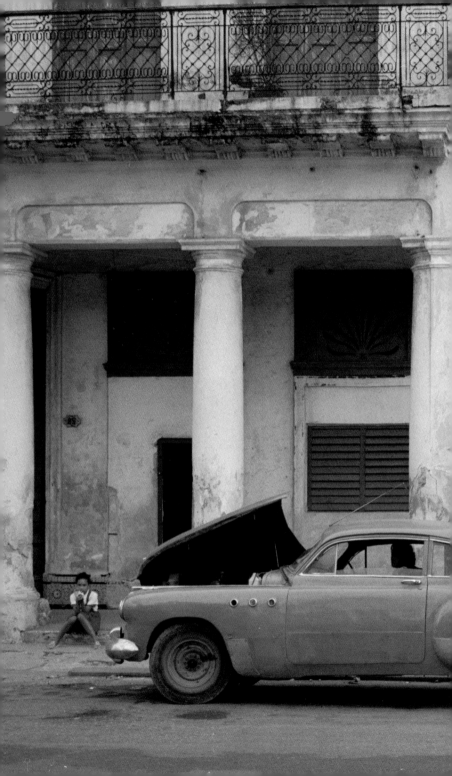

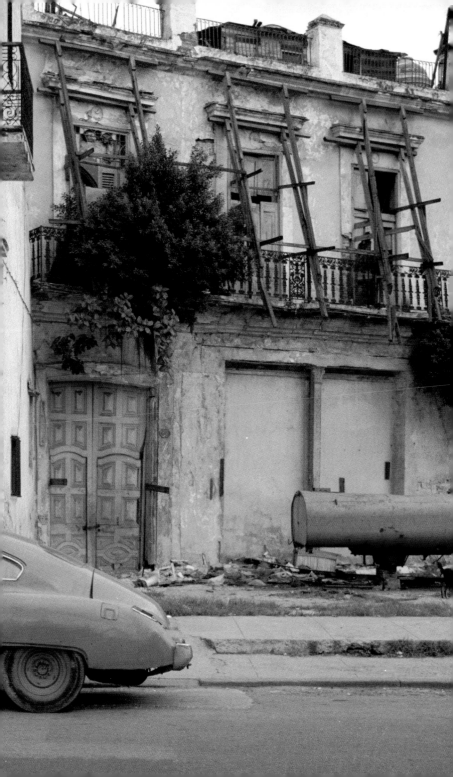

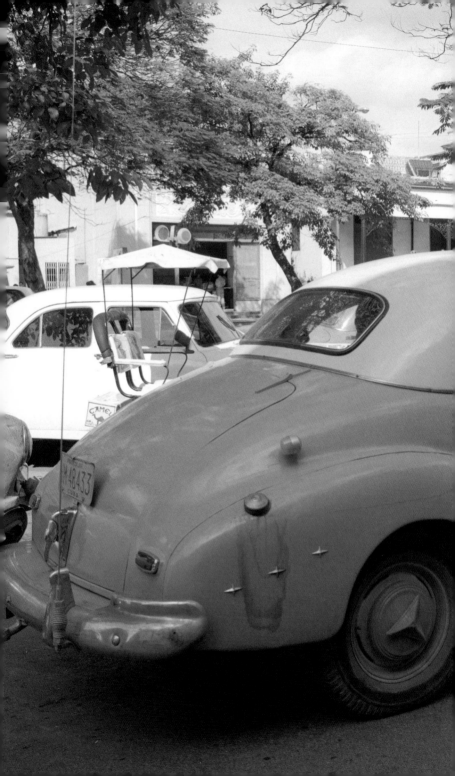

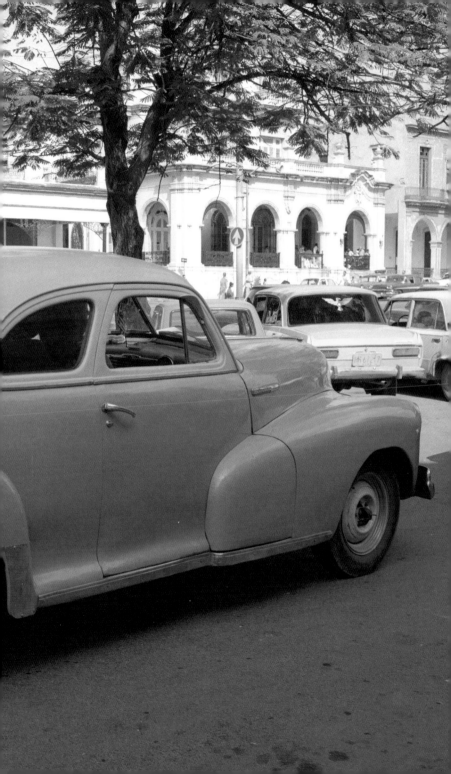

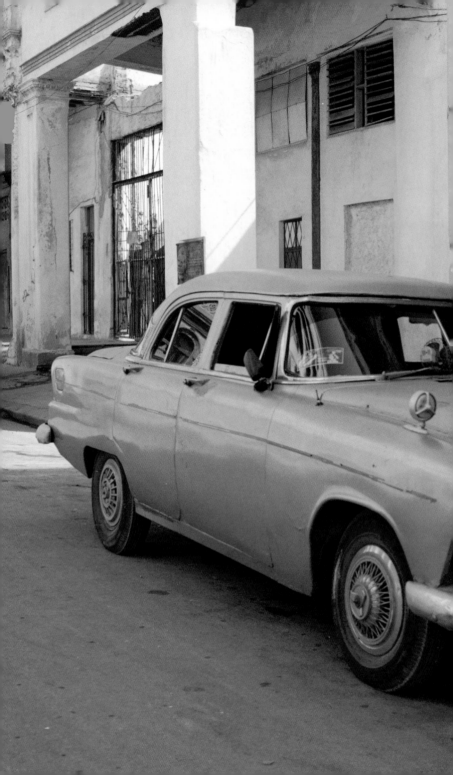

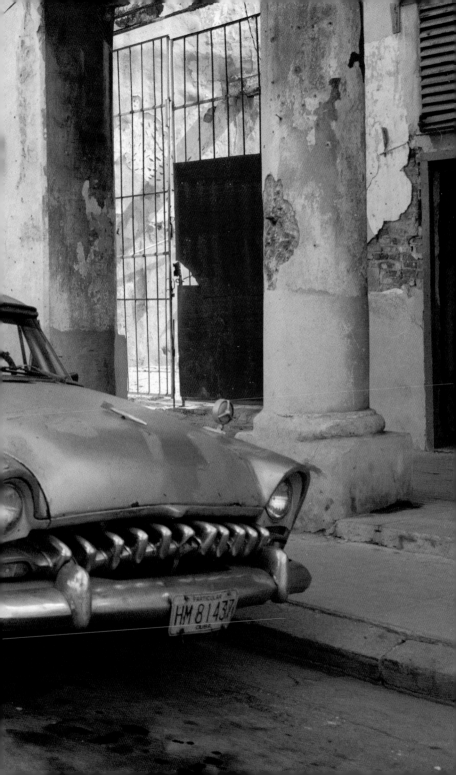

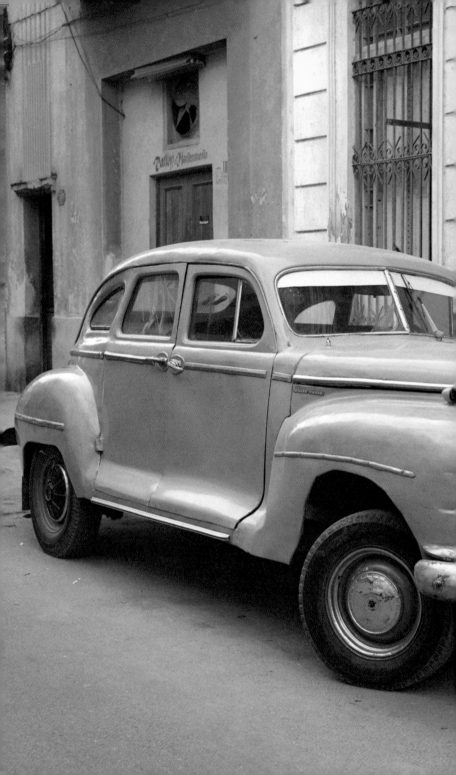

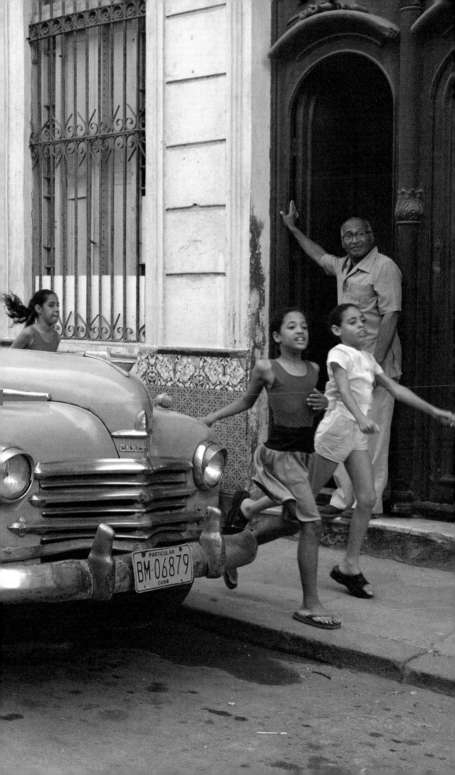

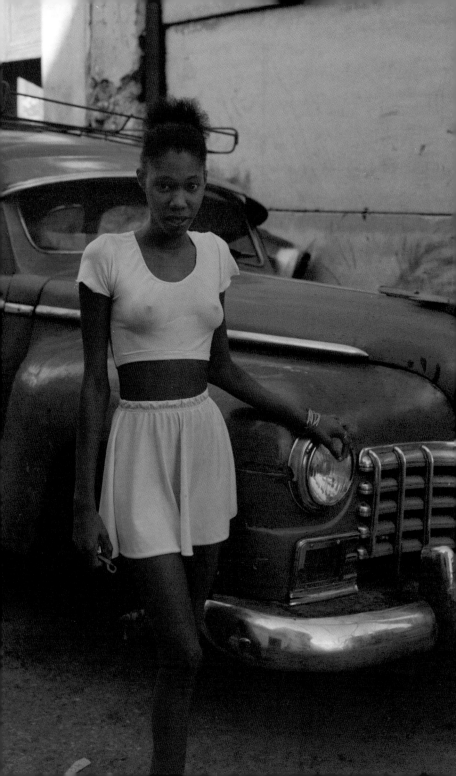

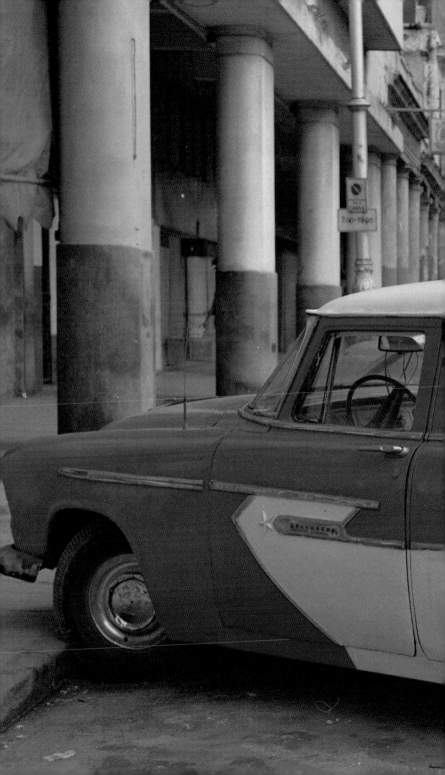

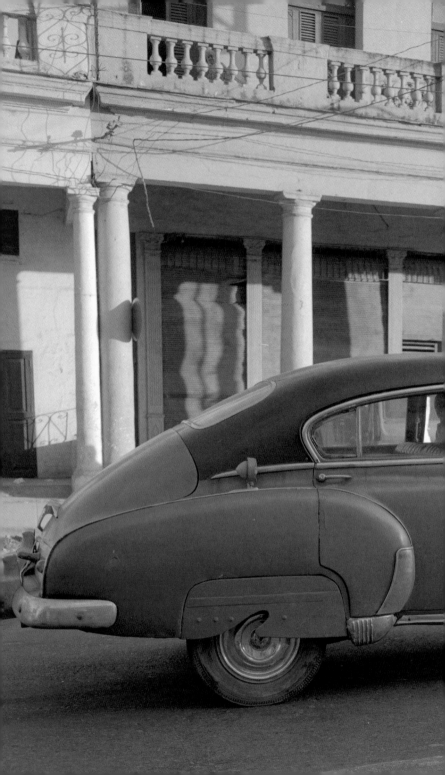

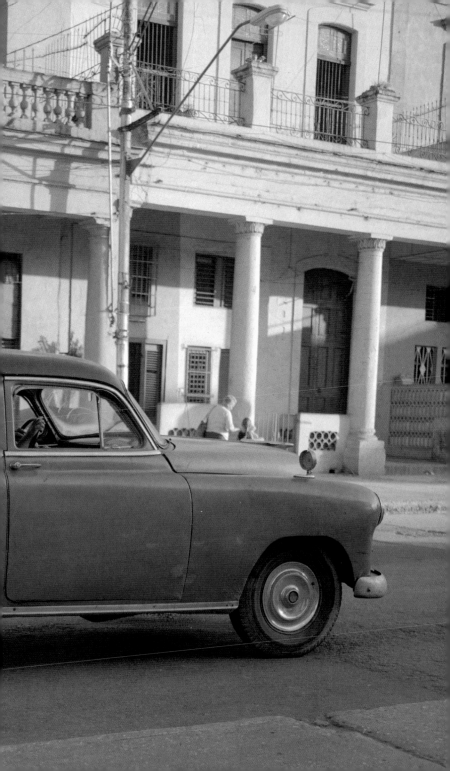

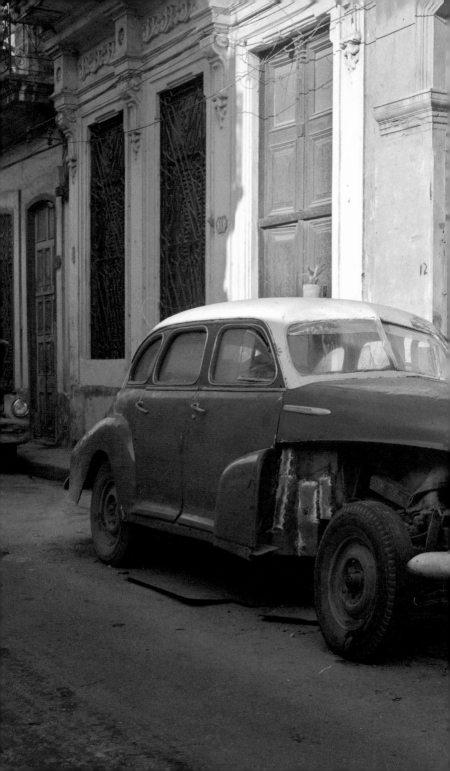

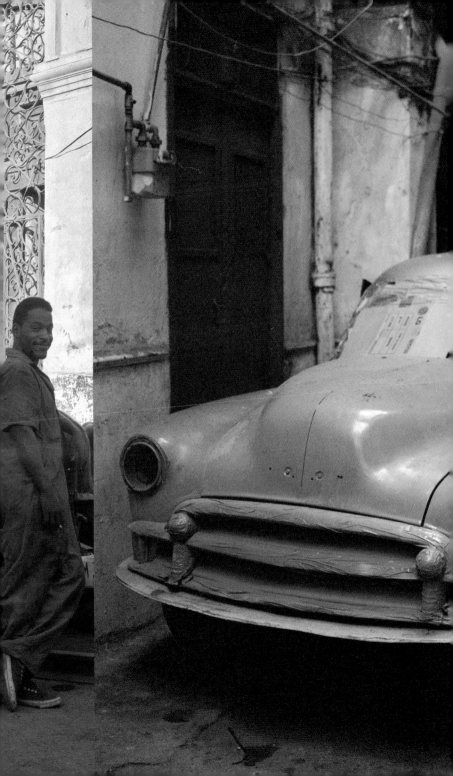

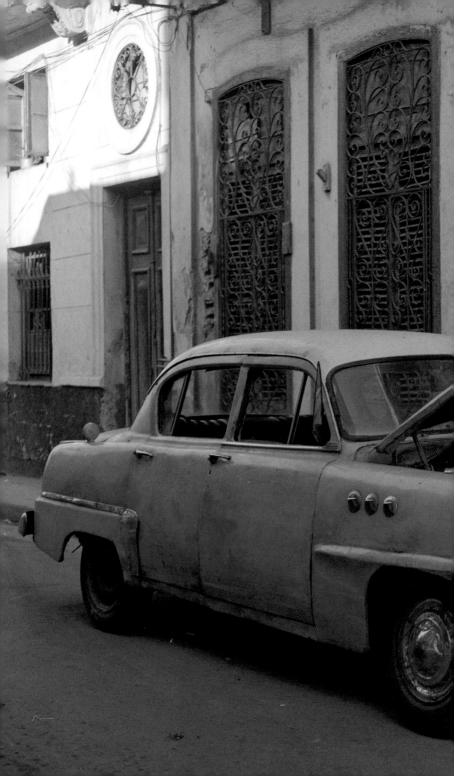

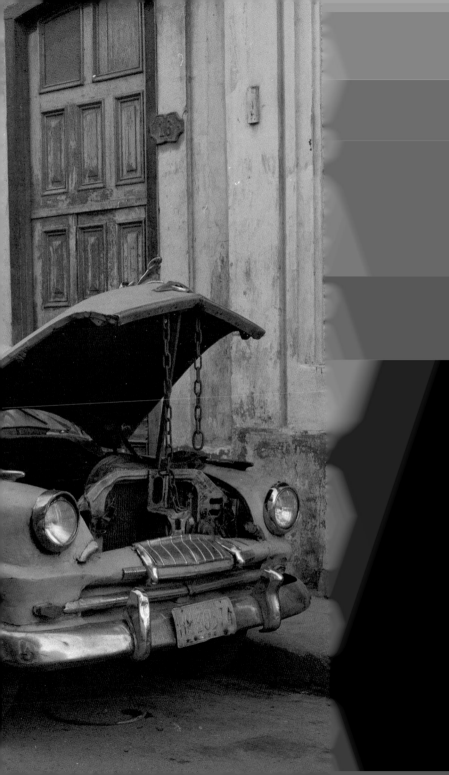

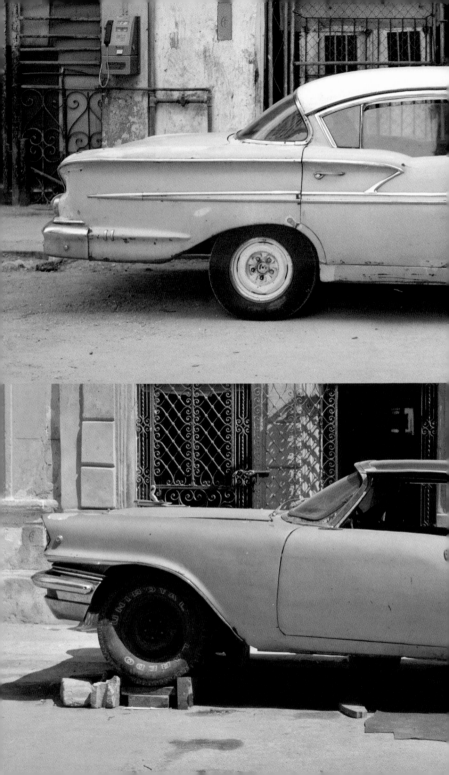

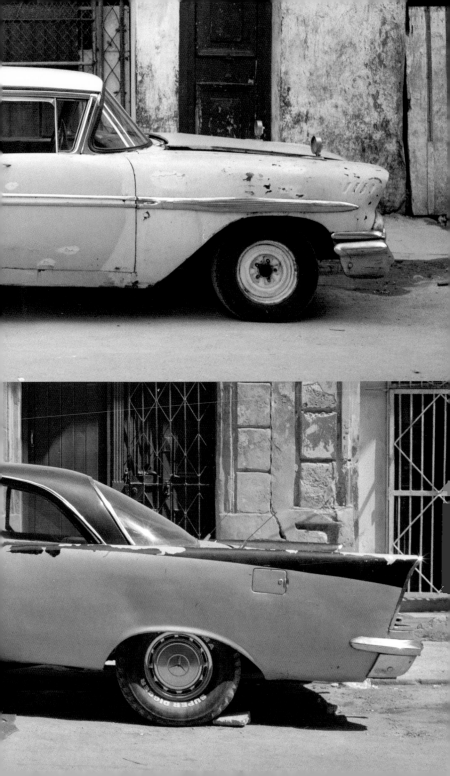

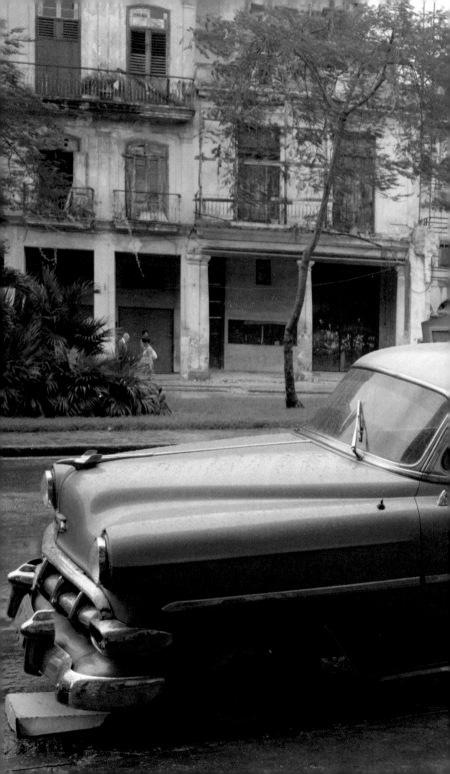

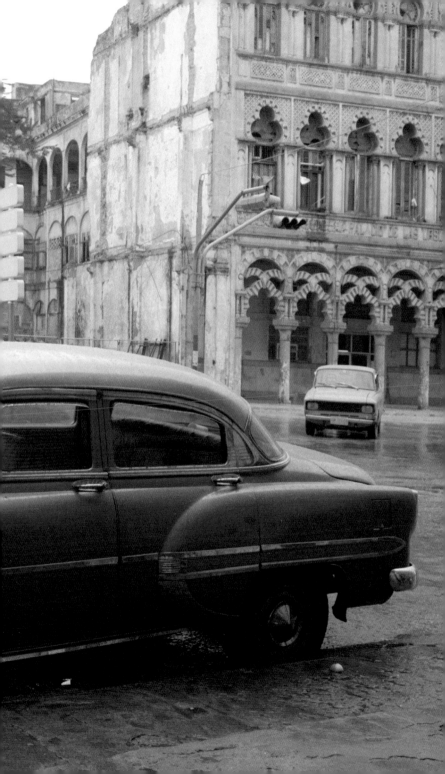

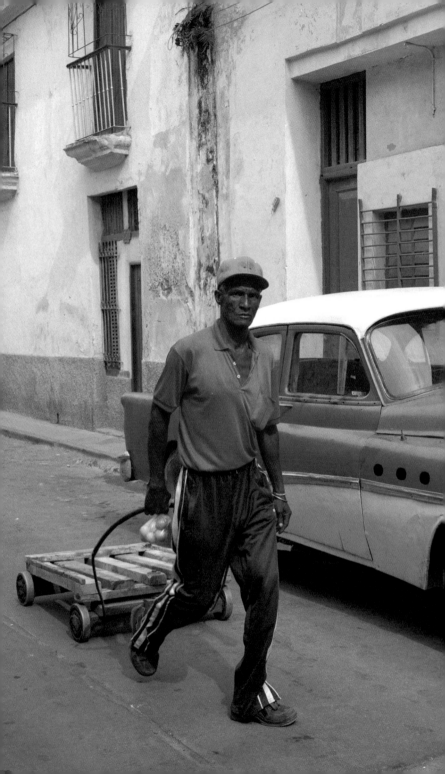

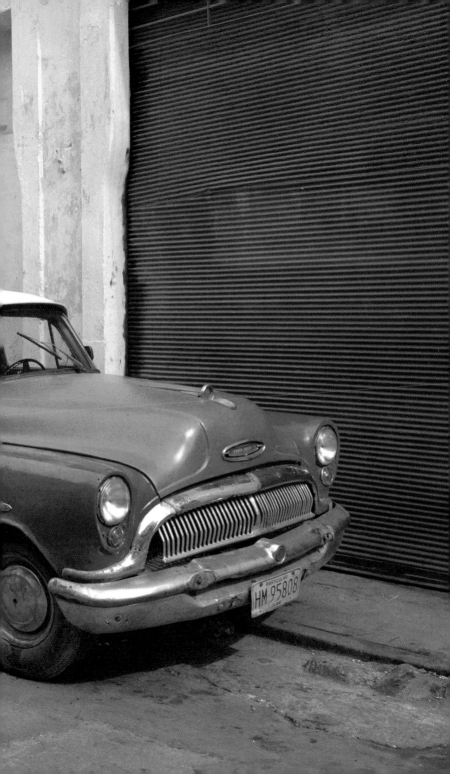

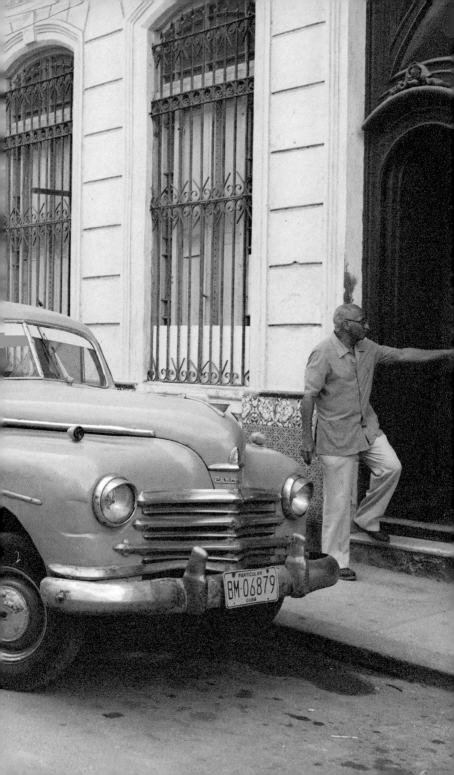

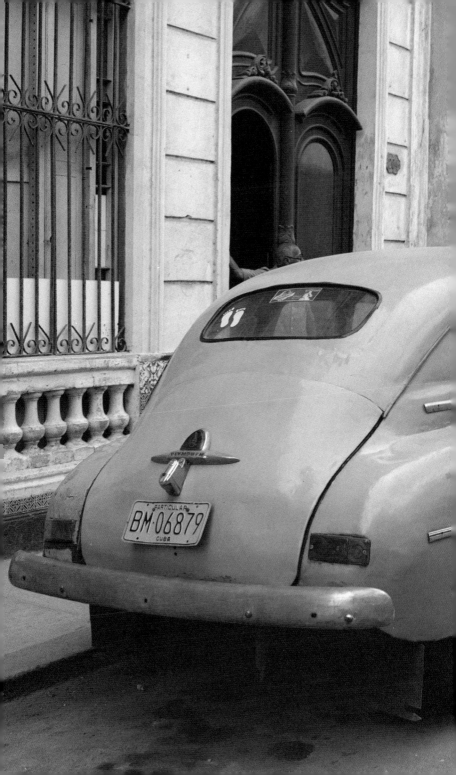

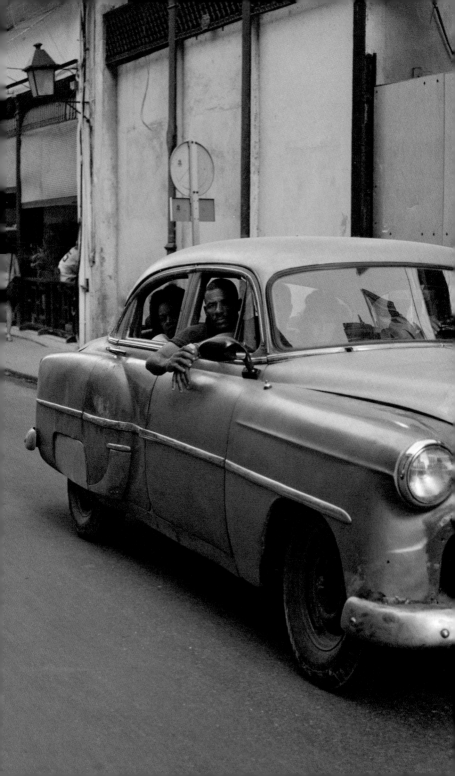

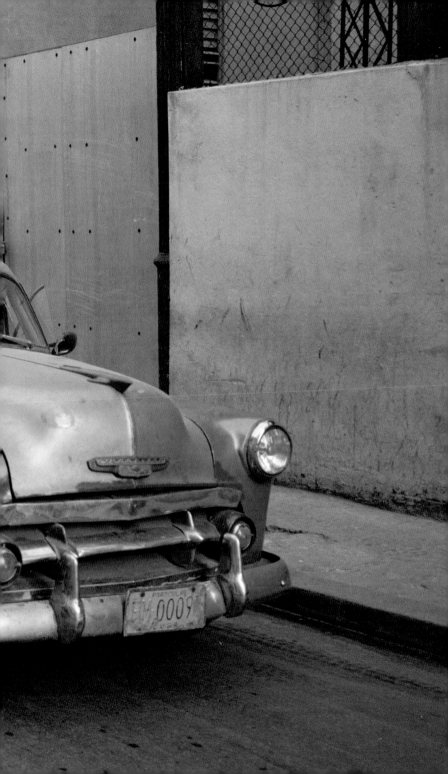

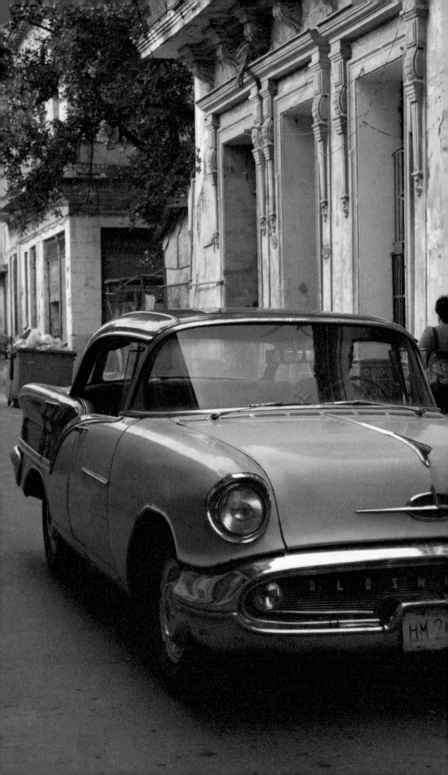

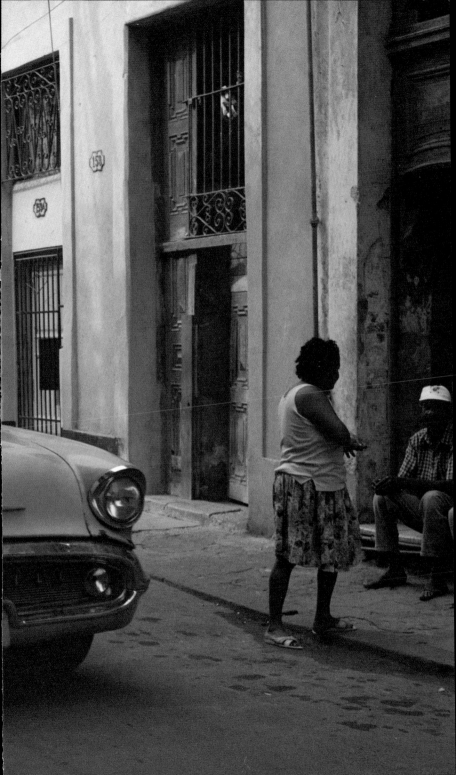

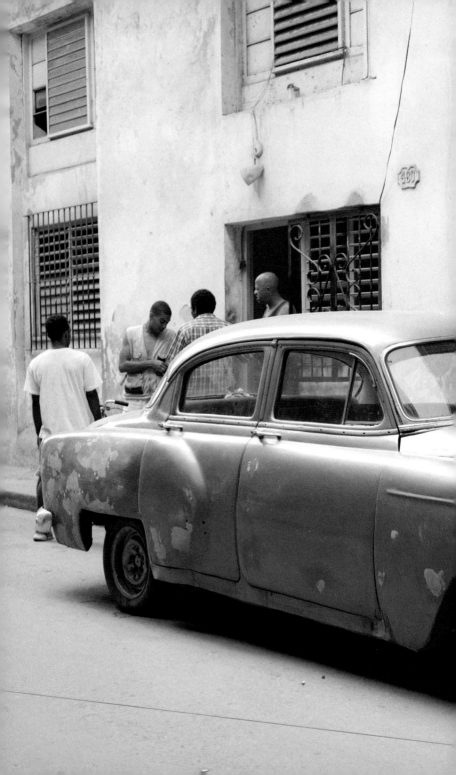

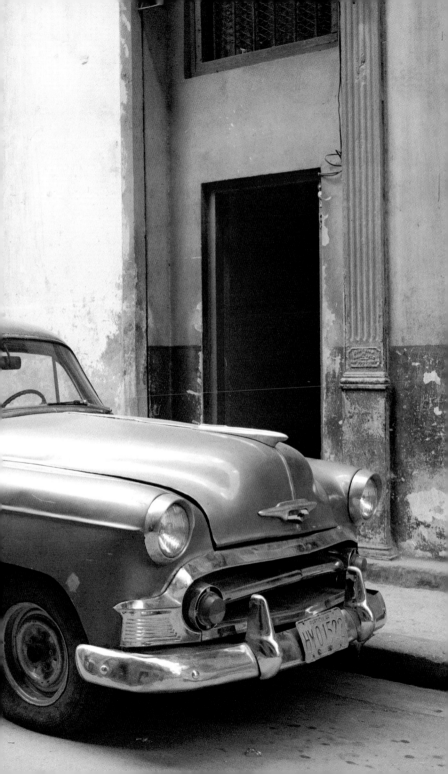

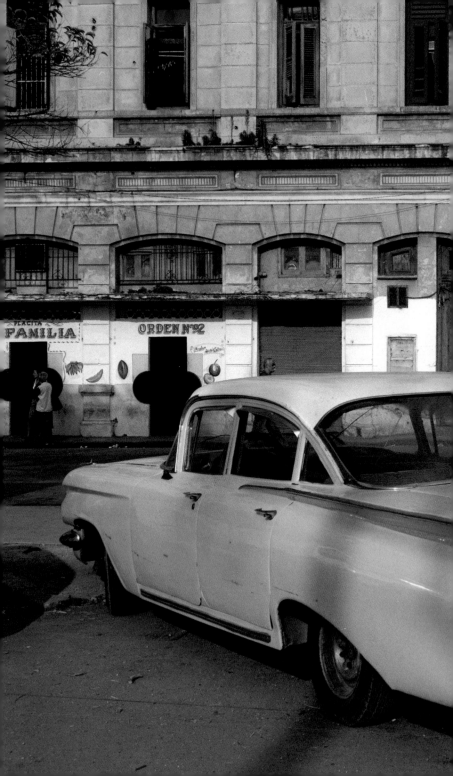

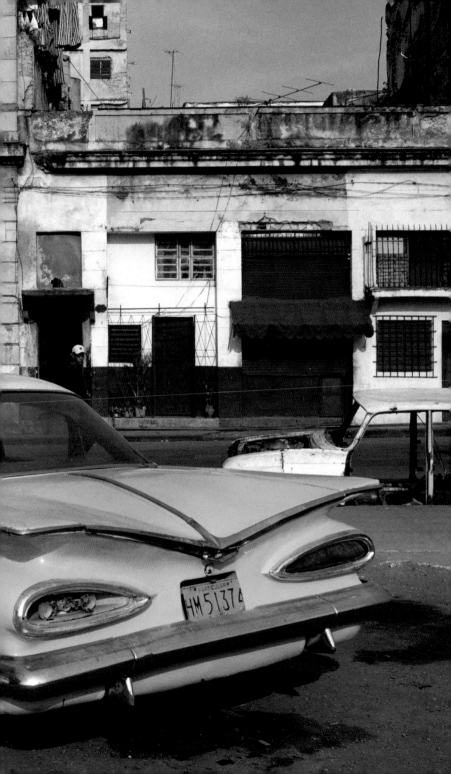

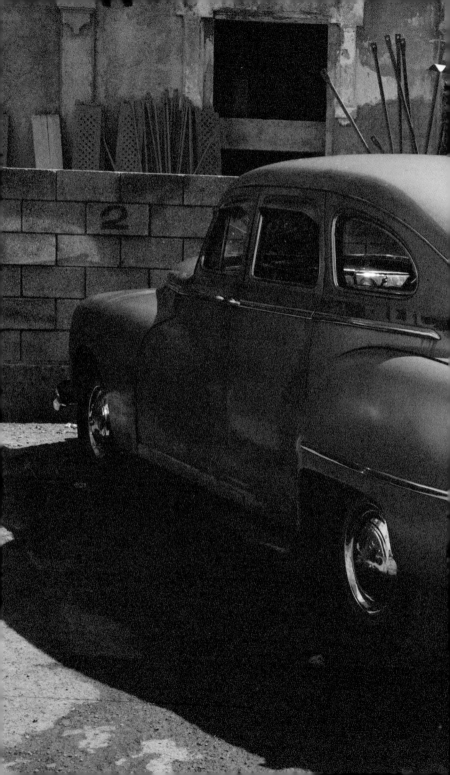

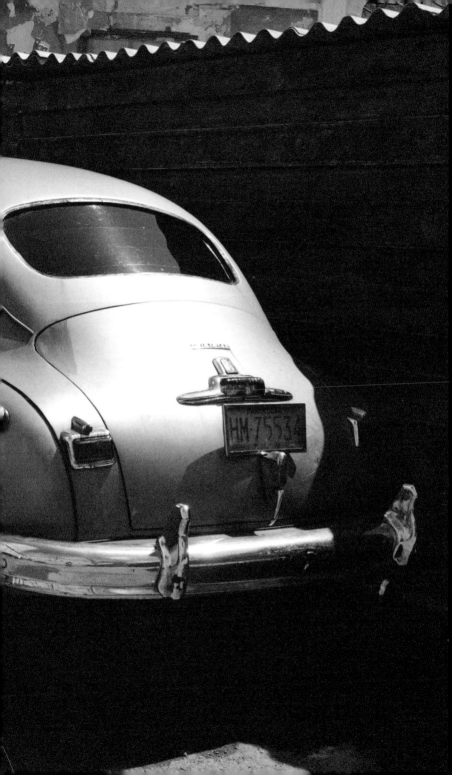

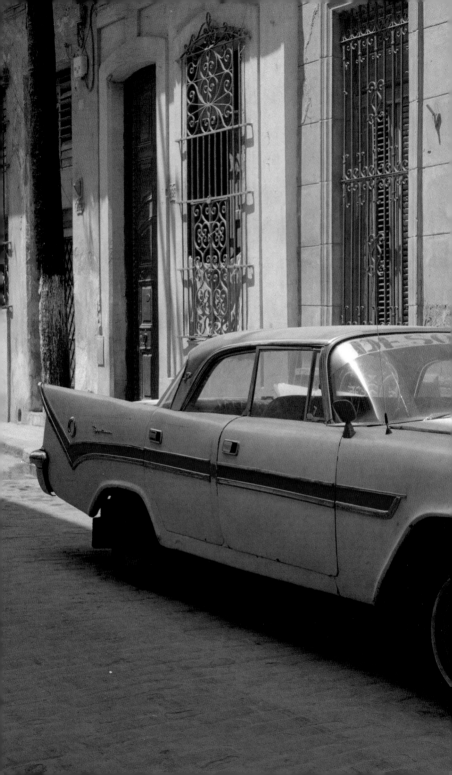

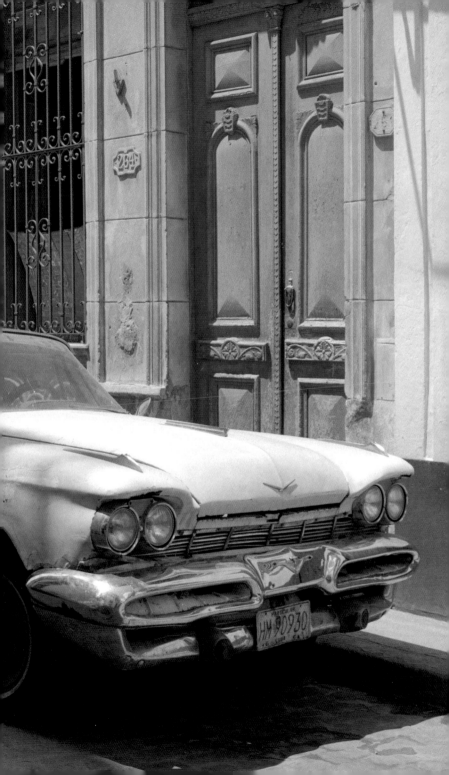

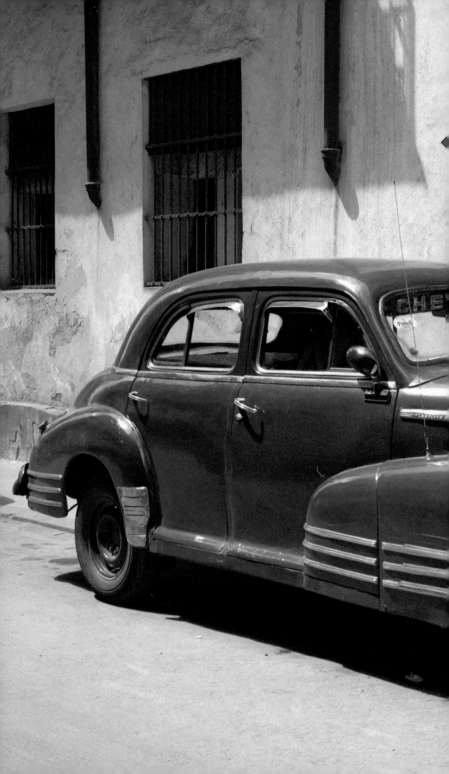

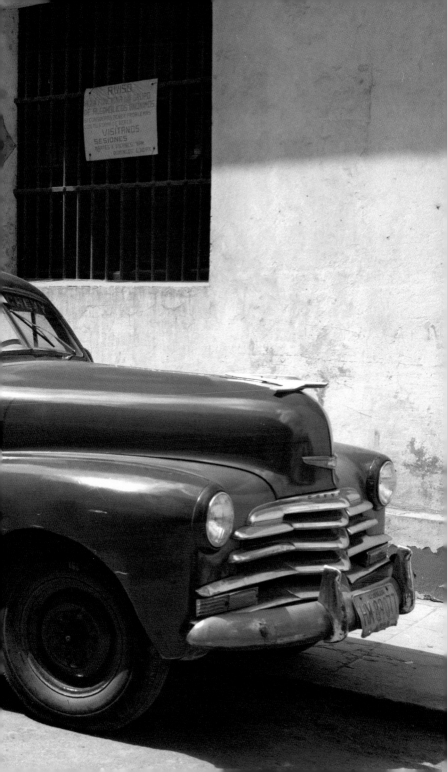

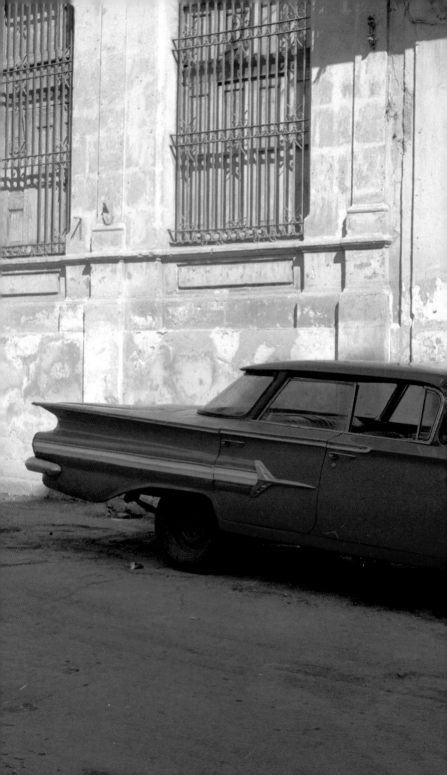

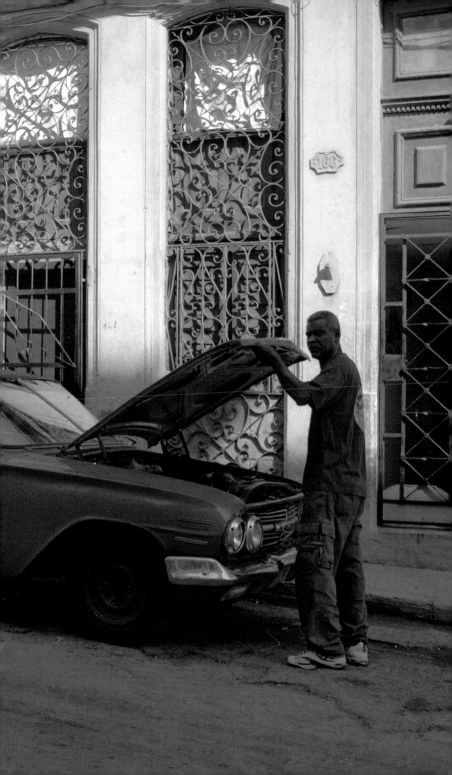

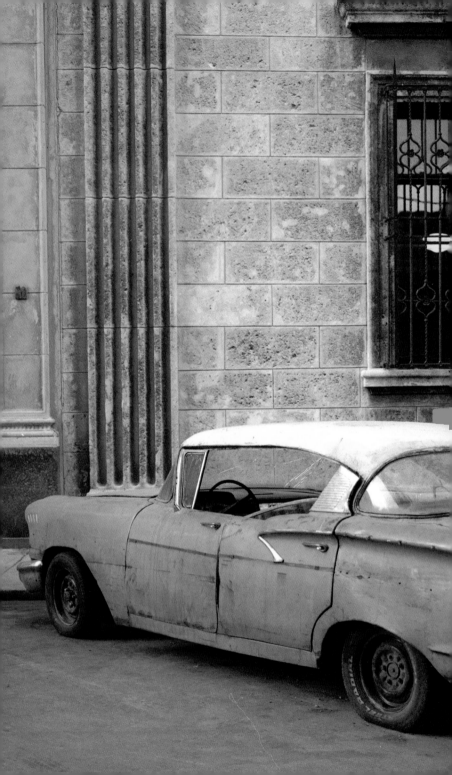

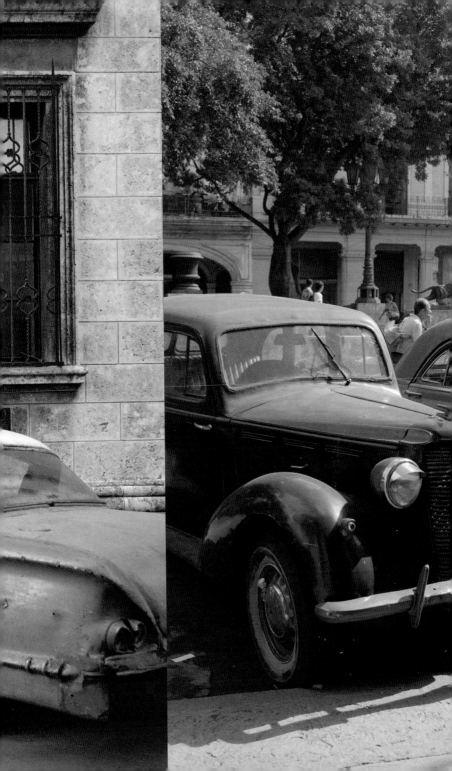

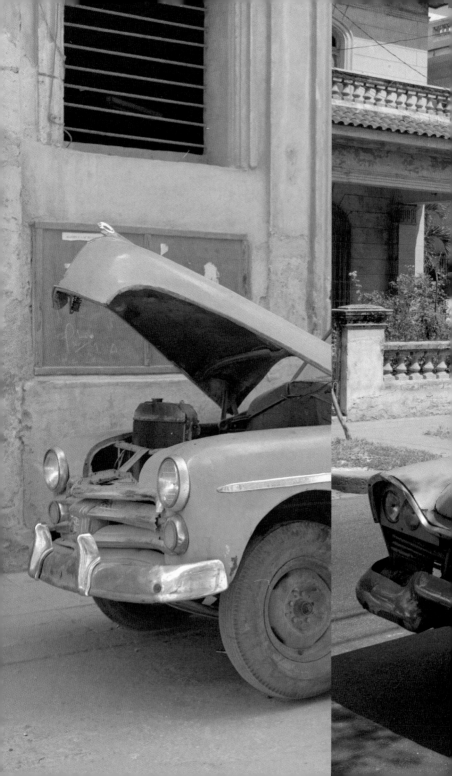

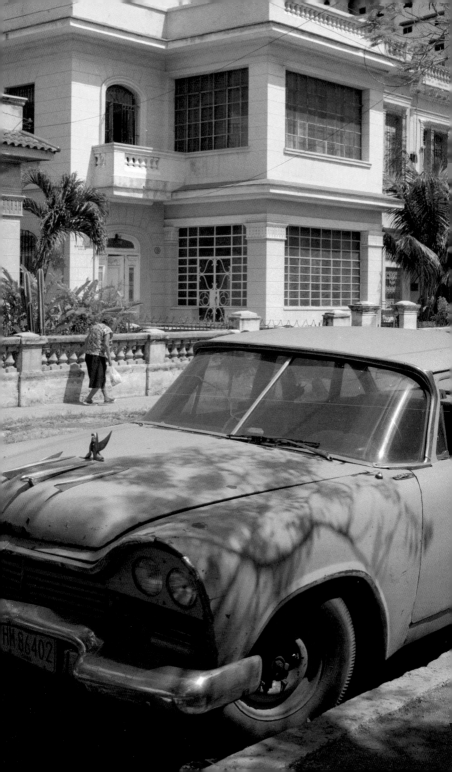

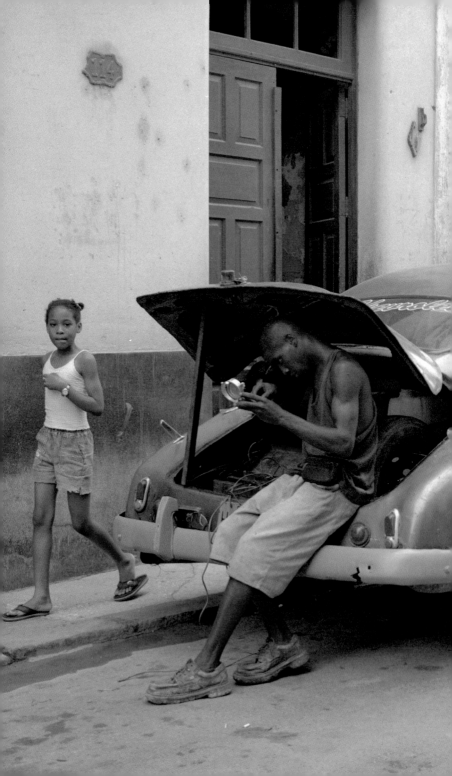

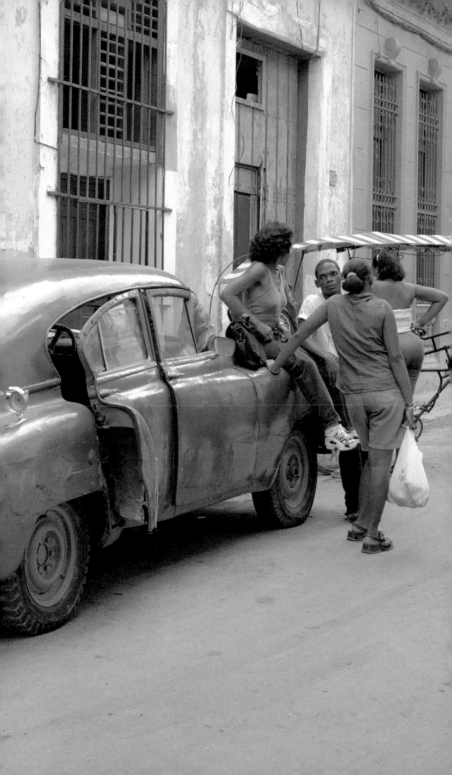

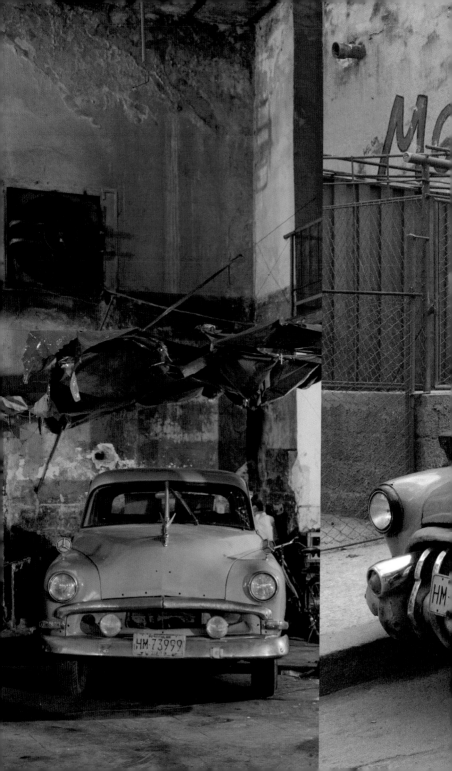

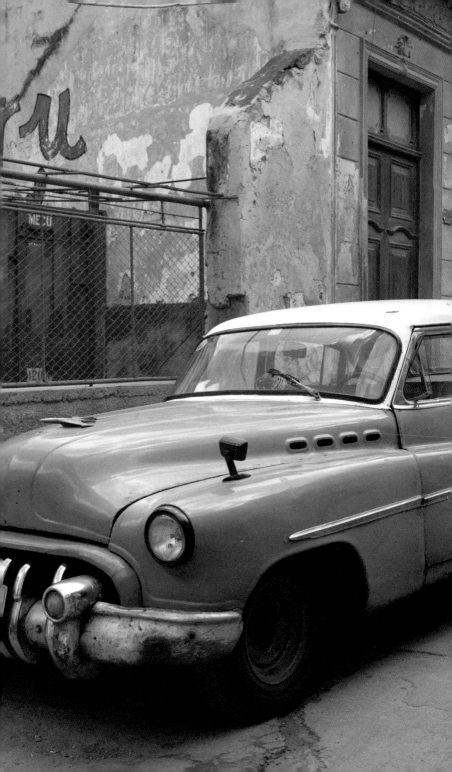

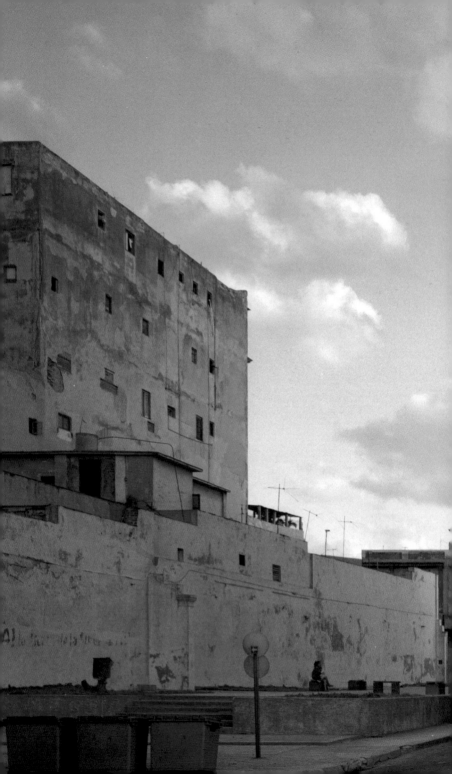

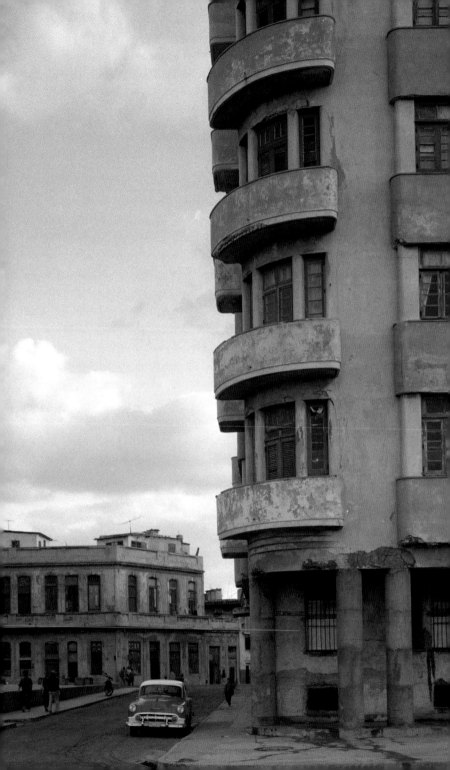

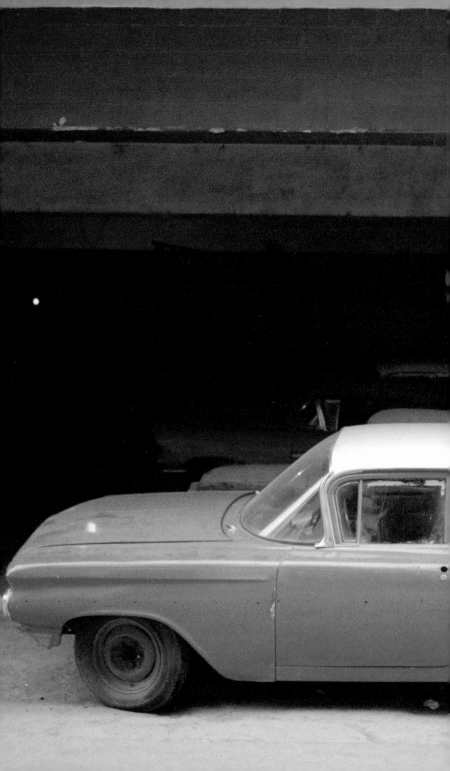

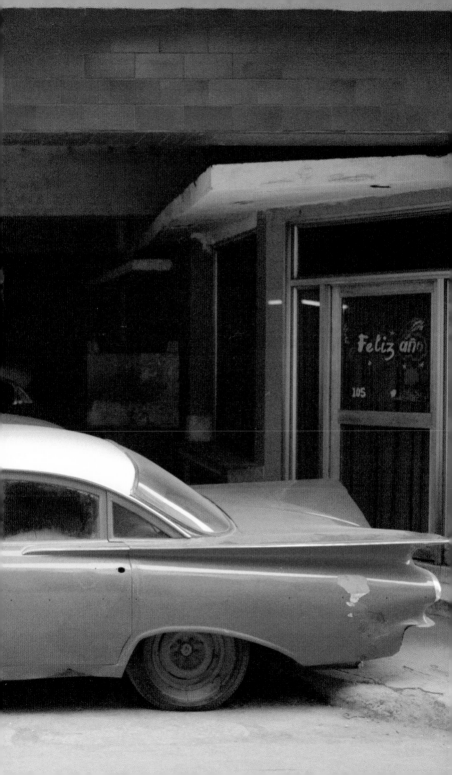

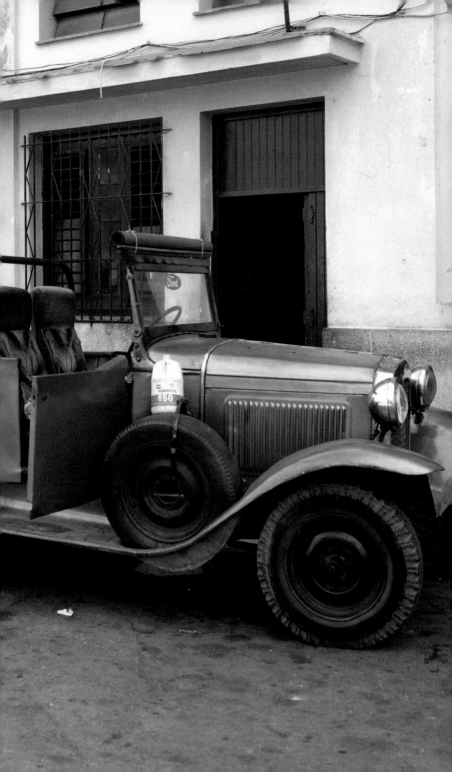

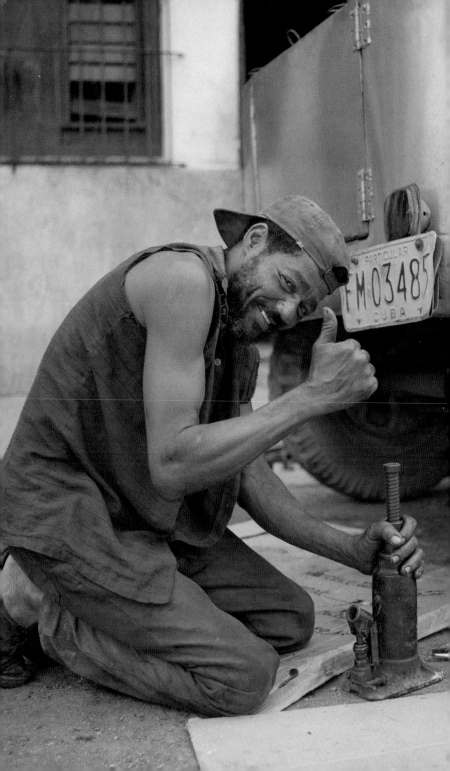

Heroes Of The Revolution
28 x 28 cm
107 photos, 132 pgs.
4 Music CDs
ISBN 3-937406-13-1

Gefällt Ihnen dieses Buch?
Noch mehr Bilder und Musik genießen Sie
im earBOOKS Großformat.

If you liked this book,
you will enjoy the large format earBOOKS
with additional music and pictures.

Si vous avez aimez ce livre, vous l'apprécierez
dans sa version earBOOKS grand format,
avec encore plus de musiques et de photographies.

CD

LOS PASOS PERDIDOS – RITMOS DE CUBA

TRÍO TESIS
Hermes Fernández Salgado: *maracas, percussion, vocals*;
René Mateo Lugos: *guitar, vocals*;
Erasto R. Torres Martínez: *tres, requinto, vocals*;

1 Oye mi son *(son)* 3:46
(Antonio Fernandez Ortiz "Ñico Saquito") Peer International Corp.

2 Ojos malignos (*trova tradicional*) 3:14
(Juan Pichardo Cambié) Editora Musical de Cuba

3 El amor de mi bohío (*guajira*) 3:43
(Julio Brito) Southern Music Publ. Co., Inc.

4 Cuidadito compay gallo (*guaracha*) 2:50
(Antonio Fernandez Ortiz "Ñico Saquito") Egrem Ediciones Musicales

5 Convergencia (*bolero tradicional*) 2:20
(Bienvenido J. Gutiérrez) Egrem Ediciones Musicales

6 Guantanamera (*guajira*) 5:14
(Joseíto Fernández) Quiroga S. L. Ediciones

7 Don Ramón (*son*) 4:02
(Bienvenido Julián Gutiérrez, Rafael Ortiz Rodriguez) Peer International Corp.

8 Tú, mi delirio (*bolero*) 3:51
(César Portillo de la Luz) Peer International Corp.

9 Que manera de quererte (*guaracha*) 4:17
(Luis Emilio Rios Morales) Editora Musical de Cuba

10 Yolanda (*canción*) 4:32
(Pablo Milanés) Autores Produtores Asociados

11 El carretero (*guajira-son*) 2:59
(Guillermo Portabales) Peer International Corp. of Puerto Rico

12 No juegues con mi santo Marilú (*son*) 5:01
(traditional)

13 Hasta siempre comandante (*canción-guajira*) 4:23
(Carlos Manuel Puebla) Egrem Ediciones Musicales

14 Son de la loma (*son*) 5:21
(Miguel Matamoros) Peer International Corp.

A production of Winter & Winter.
Producer: Stefan Winter
Executive Producer: Mariko Takahashi and Stefan Winter
℗ 2002 Winter & Winter, Munich, Germany

PHOTO INDEX

1938 Chevrolet Master

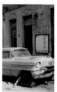

1956 Cadillac

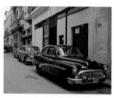

1945 Buick Roadmaster

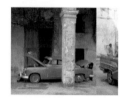

1953 Chevrolet Coupé

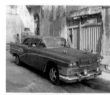

1958 Buick Special

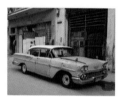

1958 Chevrolet Bel Air

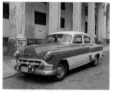

1953 Chevrolet Bel Air

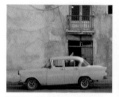

1955 Chevrolet Bel Air

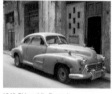

1948 Oldsmobile Dynamic

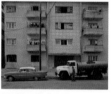

1955 Oldsmobile Super 88

1955 Plymouth Belvedere Station Wagon
1951 Chevrolet Styleline

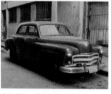

1951 Chevrolet Styleline

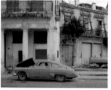

1949 Buick Special

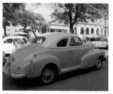

1946 Chevrolet Stylemaster

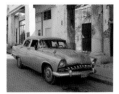

1956 Pakkard Clipper

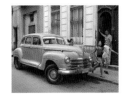

1946 Plymouth Special

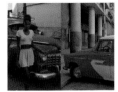

1946 Dodge Custom
1956 Plymouth Belvedere

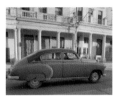

1949 Buick Sedanet

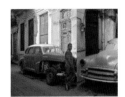

1948 Chevrolet Fleetline
1950 Chevrolet Styleline

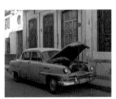

1953 Plymouth Cambridge

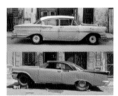

1958 Chevrolet Bel Air
1958 Chrysler Windsor

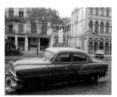

1954 Chevrolet Bel Air

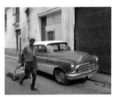

1953 Buick Roadmaster

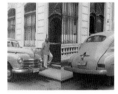

1946 Plymouth Special

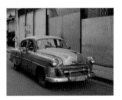

1953 Chevrolet Deluxe

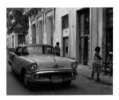

1957 Oldsmobile Super 88

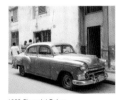

1953 Chevrolet Deluxe

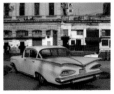

1959 Chevrolet Bel Air

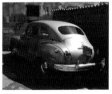

1946 Chevrolet Aerosedan

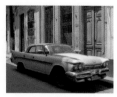

1959 Desoto Adventurer

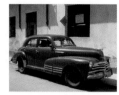

1948 Chevrolet Fleetline

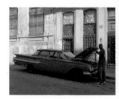

1960 Chevrolet Impala

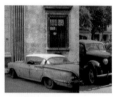

1958 Chevrolet Bel Air
1937 Pontiac Deluxe

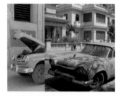

1947 Chevrolet Sedan
1958 Plymouth Fury

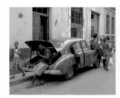

1949 Buick Super Sedanet

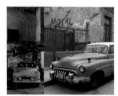

1953 Chevrolet
1950 Buick Roadmaster

1953 Chevrolet Bel Air

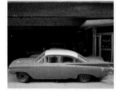

1959 Chevrolet Impala

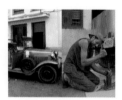

1929 Ford "A" modified

Editorial note:
Because many cars on the Cuban island have been modified by their owners
over many years, we were not able to precise the exact specifications of each
car that is shown in the photographs. If you are able to provide us with more
detailed information, we would be very grateful. Please contact us via email:
earbooks@edel.com

Many thanks for your help!
The edel Classics team